ARenon

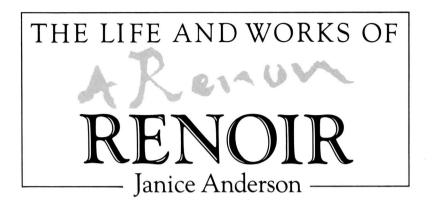

A Compilation of Works from the BRIDGEMAN ART LIBRARY

Shooting Star Press Inc 230 Fifth Avenue, New York, New York 10001

Renoir

This edition first published in Great Britain in 1994 by Parragon Book Service Limited

© 1994 Parragon Book Service Limited

All rights reserved. No part of the publication may be reproduced, stored in a retrieval system, or transmitted in any way or by any means, electronic, mechanical, photocopy, recording or otherwise, without the prior permission of the copyright holder.

ISBN 1858135362

Printed in Italy

Editorial Director: Designer:

Lesley McOwan Robert Mathias

Production Director: David Manson

AUGUSTE RENOIR 1841-1919

ARenov

ALTHOUGH PIERRE AUGUSTE RENOIR was one of the founders of Impressionism and a revolutionary among painters, his real ambition, which he did not discover until 1881 when he visited Italy, was to be an artist in the grand Renaissance tradition of Titian. Until he went to Italy, his painting was decorative in style, with a delicate sense of colour he had developed while an apprentice porcelain painter.

Renoir was born in Limoges on 25 February 1841. His father was a tailor who moved to Paris, where the 14-year-old Renoir was apprenticed to a firm of porcelain painters. His natural talent for colour was given a new direction when he passed the Ecole des Beaux- Arts entrance exam and joined Charles Gleyre's studio, where he met many young artists who would later be labelled Impressionists.

The early work of these young painters was derided by the art establishment of Paris and refused entry to the official Salon. To make a living, Renoir painted conventional portraits but also exhibited his Salon rejects at the Salon des Refusés.

At Gleyre's studio, Renoir had become a good friend of Claude Monet and they began to paint together, notably at Argenteuil, near Paris, where Monet had a house which became a meeting-place for young painters.

In 1874, tiring of the Salon's rejections, several young painters, including Renoir, Monet, Sisley and Berthe Morisot, organised an exhibition of their own. Renoir included seven paintings in this exhibition, which was not a financial success but which did get the painters their name, 'Impressionist', at first given them as a term of derision.

At the second Impressionist Exhibition in 1876 Renoir showed 15 works. At this period he was becoming increasingly successful, with his painting of *Madame Charpentier and Her Children* achieving a notable success in the 1879 Salon.

Then came his visit to Italy in 1881. He was so overwhelmed by the work of the Italian Renaissance painters, whom he encountered for the first time, that he decided he knew nothing about drawing and very little about paint. From now on, he would tighten his line and gradually give up the Impressionist way of applying paint in small strokes of colour, using instead the traditional method of putting it on in layers and glazes.

A visit to Cézanne at L'Estaque near Marseille on his way home from Italy confirmed him in his new approach, for Cézanne had broken away from Impressionism to develop a severe structural style of his own. Renoir now concentrated on developing his own new techniques. His *Umbrellas*, painted over several years in the early 1880s, was a formal composition full of the planes of colour and tight structure of a Cézanne painting.

Realizing that tight drawing and rich colour were incompatible, Renoir concentrated on combining what he had learned about colour during his Impressionist years with traditional methods of applying the paint. The result was a series of masterpieces very much in the tradition of Titian, as well as Fragonard and Boucher, whom he admired. There was much critical praise for the work

Renoir included in a one-man show of 70 organized by the dealer Paul Durand-Ruel, and his first official recognition came when the French state bought *At the Piano* in 1892.

In 1885 a son, Pierre, had been born to Renoir and his long-time mistress and model, Aline Charigot. Three years later, visiting Cézanne at Aix-en-Provence, Renoir discovered Cagnes which became his winter home when he began suffering from arthritis and rheumatism. He spent long periods in the south with Aline, now his wife, adding two more boys to his family: Jean, born in 1894, who was to become one of France's greatest film directors, and Claude (Coco) born in 1901. The house at Cagnes, Les Collettes, which the Renoirs built in 1907, was to become an important haven for work and home life.

As Renoir's arthritis worsened, he found it increasing difficult to hold his brushes and eventually had to have them strapped to his hands. He also took up sculpture, in the hope that he could express his creativity through modelling, but even in this he needed help, which came from two young artists, Richard Gieino and Louis Morel,

Despite his severe physical disabilities, Renoir continued working up to the last year of his life. His great canvas in the Louvre, *The Bathers*, was completed in 1918. In 1917, he was visited by a young painter called Henri Matisse, who was destined to carry forward his ideas of colour into a new era. Renoir died at Cagnes on 3 December 1919. He was 78 and recognized as one of the greatest of French painters.

who worked under his instructions.

▷ Alfred Sisley and His Wife 1868

Oil on canvas

ALFRED SISLEY was among the Impressionists who gathered round Monet and Renoir at Argenteuil. He was a quiet, rather reserved Englishman who, on the whole, preferred to work in solitude rather than in an artistic milieu. Perhaps he was rather overwhelmed by the gallic exuberance of his fellow painters, although he certainly shared their ideas and was a good friend of both Monet and Renoir. Renoir's painting of the newly-married

Sisley and his wife, Marie, was probably done during an outing to the Forest of Fontainebleau in 1868. It reveals the talent for portraiture which earned Renoir his keep while he was developing the techniques which would make him a master painter, and it also shows him at home with the Impressionists' insistence on painting portraits of people in naturalistic and even unconventional attitudes.

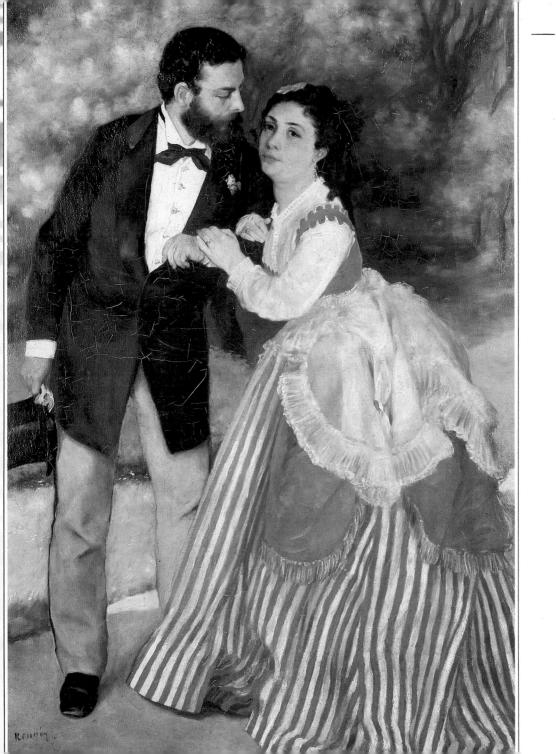

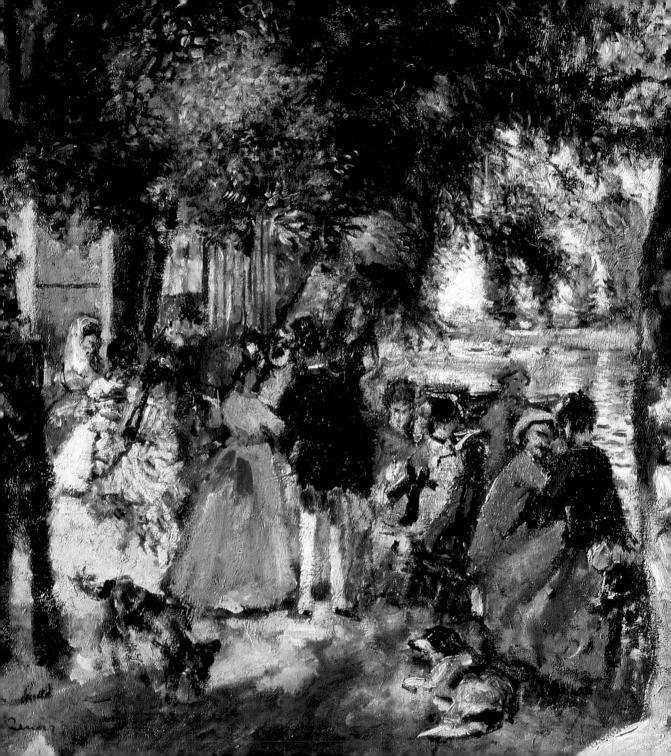

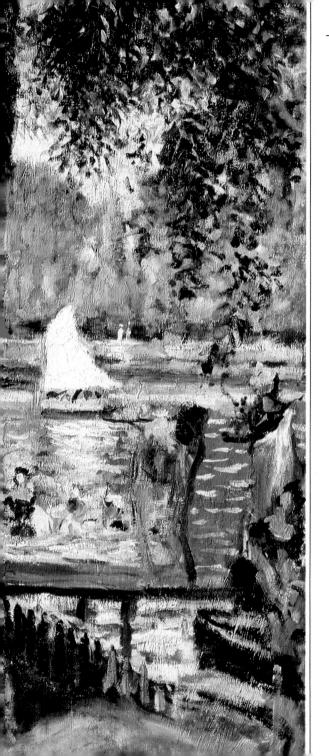

△ Bathers in the Seine, La Grenouillère 1869

Oil on canvas

THIS POPULAR SPOT on the Seine was also the subject of paintings by Monet, which is not surprising since the two young friends often frequented the café-boating place together. The broken streaks of paint used to describe the reflections in the water and the loose handling of the paint is typical of the early Impressionist technique which was occupying the minds of the revolutionary young painters. The effect is to give the viewer an instant and lively impression of the location and the open air.

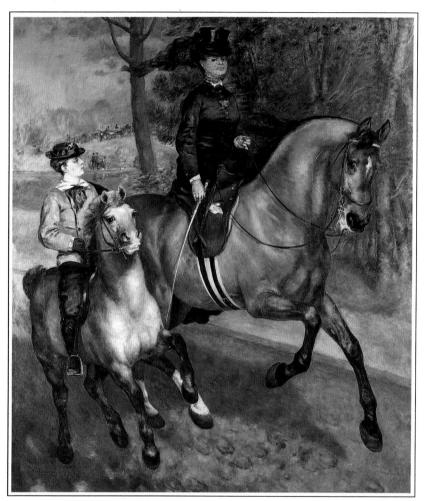

Oil on canvas

THESE ELEGANT RIDERS belong to the period when Renoir was making a living by painting conventional, modern-life pictures for wealthy patrons, as well as doing his own experimental Impressionist work. The riders are models, playing the part of the affluent kind of people to be seen in the Bois de Boulogne. Paintings of this kind would naturally appeal to the fashionable public, the kind of people who might well have regarded Renoir's paintings of boating parties and other pursuits of ordinary people as slightly vulgar.

> **La Loge** 1874

Dil on canvas

THE LIFE OF FRANCE'S affluent niddle classes, who had become wealthy from trade and commerce, fascinated the numbly-born Renoir. Even so, ie used a Montmartre model called Nini guele en raie and his prother Edmond to pose for La Loge. In this artistic tour de force Renoir portrays a well-off voman in a box at the opera in all her finery and attended by a smart, sophisticated manabout-town. It is not difficult to magine the kind of life this pulent couple would have led in their smart Paris flat, no doubt on one of the new treefringed avenues laid out by Baron Haussman. These were the kind of people who bought Renoir's paintings and commissioned portraits from him, and he admired them as much as he depended on them for work. Despite Renoir's traditional treatment of the subject, using thin, delicate layers of colour to achieve the required effect, he exhibited La Loge in the first Impressionist Exhibition in 1874.

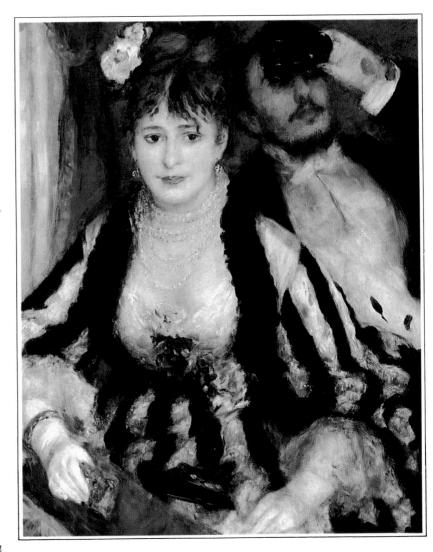

Detail

▶ Alfred Sisley 1874

Oil on canvas

Sisley had been a good friend of Renoir's since they met as young students at Gleyre's studio, despite their different temperaments. Sisley, though born in Paris in 1839, had English parents, and was more phlegmatic than Renoir. As his father was a well-off businessman Sisley at first did not have the financial worries of Renoir; these came later

when his father died and his painting qualities were still not recognized. Though Sisley worked occasionally in England his main themes were the places where the Impressionists gathered along the Seine at Argenteuil, Bougival and Marly. Sisley died in 1899, before his work was fully recognized.

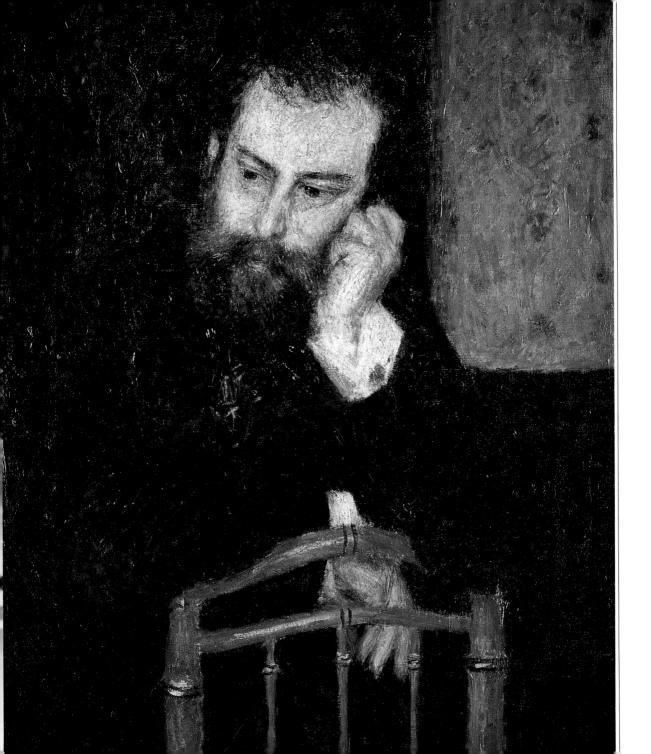

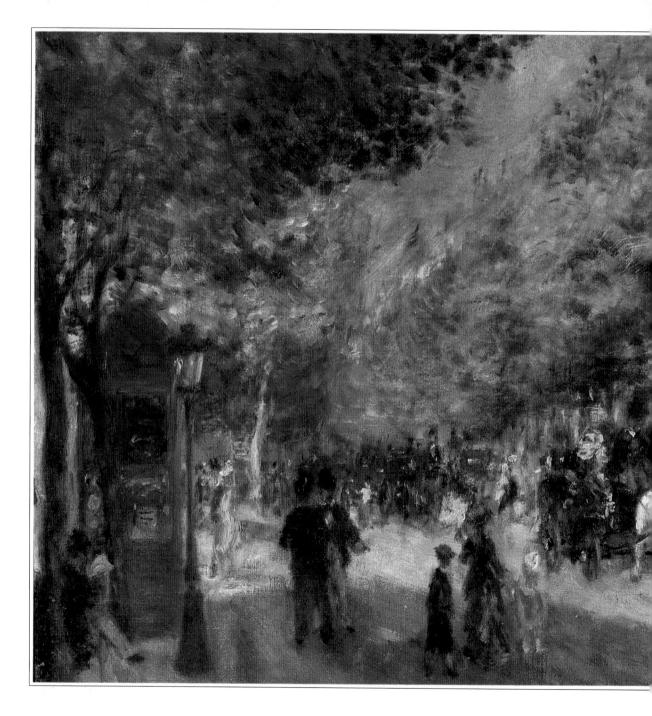

△ Les Grands Boulevards 1875

Oil on canvas

THE MAKING OF the grands boulevards by Baron Haussman under the orders of Napoleon III changed the face of Paris. Small medieval blocks of houses were torn down to make wide avenues crisscrossing the city, and, it was said, allowing better control of possible rioters. In fact, the grands boulevards became the great social centres of Paris,

where the rich paraded in their horse-drawn coaches and the ordinary citizen promenaded or sat at cafés to watch the world go by. Renoir's lively picture of the boulevards preceded that of Monet, and was just one of numerous cityscapes and scenes of Parisian life Renoir painted in the 1860s and 1870s.

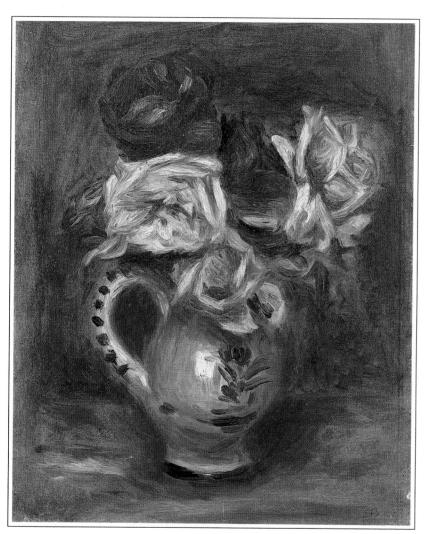

Oil on canvas

RENOIR WAS FASCINATED by flowers, especially roses, which in later life he grew at his property in Cagnes so he could paint them every day, nourishing a passion for the flower formed in the 1870s. In this study of roses in a ceramic jug Renoir was evidently looking at the colour of the unfolding roses as their petals caught the light and contrasting their soft warmth with the cooler tones and curves of the jug. The table on which the vase is standing and the background are treated in a rather perfunctory way, which seems to confirm that Renoir's main interest was a study of roses.

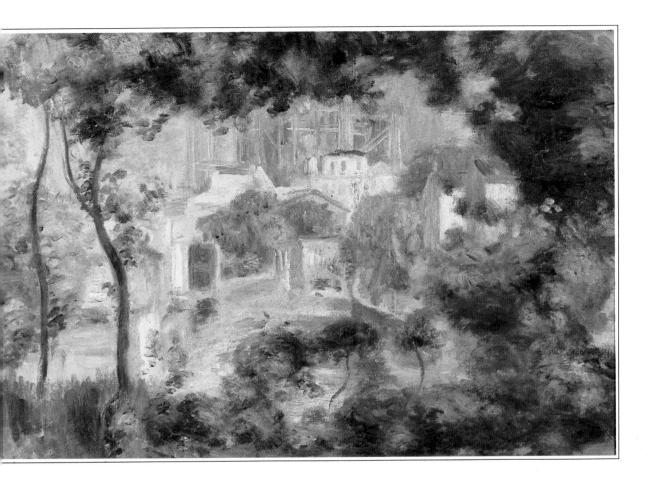

△ Looking Out at the Sacré Coeur c.1876

Oil on canvas

WHEN RENOIR and his friends were living at Batignolles he painted a series of Paris pictures. This one shows the church of Bacré Coeur on the summit of the Butte de Montmartre. At the

time, this was still country outside the jurisdiction of the city, and attracted many people who wanted to avoid its laws and taxes. Today, Montmartre is totally built over but a vineyard still survives, as does an Impressionist haunt, the country inn known as Lapin à Gil – Gil's Rabbit – a reference to the inn sign painted by someone called Gil.

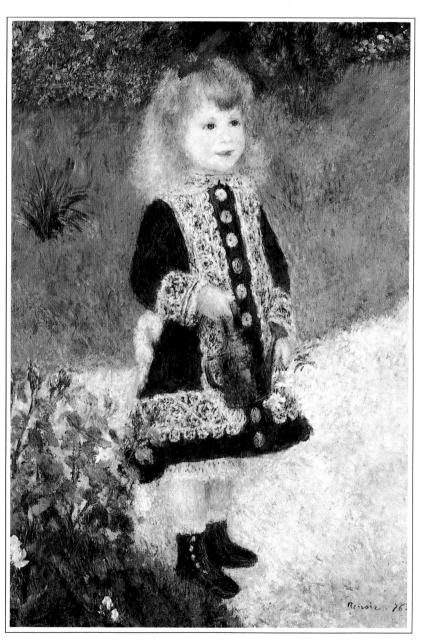

△ A Girl with a Watering-can 1876

Oil on canvas

MADEMOISELLE LECLERE in her smart blue dress was probably the daughter of one of the rich patrons who bought Renoir's paintings. This charming portrait of her is painted with that special empathy that Renoîr had with children and, quite unlike his nudes, has a very personal feeling. The child's golden hair is contrasted nicely with the green background and the blue of her dress. There is a certain stiffness about the picture which suggests the child was holding herself still with an unconscious impatience: unlike Renoir's other models, who seemed to have infinite patience, Miss Leclere would not be standing there, flowers and wateringcan in hand, for very long.

▶ Girl with a Cat 1876

Oil on canvas

CHILDREN WITH ANIMALS featured in several of Renoir's paintings, and the theme of the girl with a cat turned up again in a painting of Julie Manet (Berthe Morisot's daughter), some ten years after this charming picture. With both paintings, Renoir took the trouble to make preliminary sketches; a sketch of this painting was put up for sale at Sotheby's in London in 1968. In the sketch, the tabby is quite a big cat; by the time the painting was finished, it had changed into a large kitten with more strongly defined tabby markings.

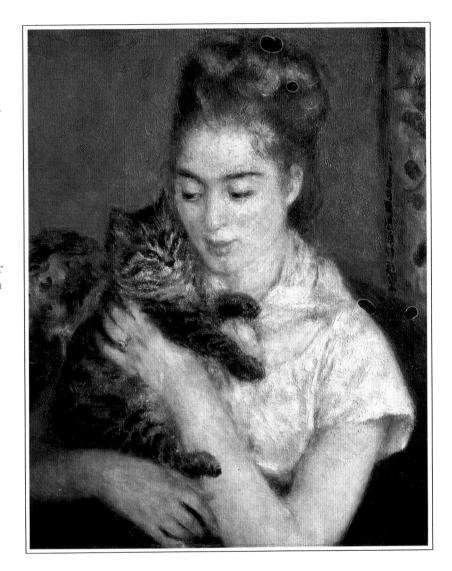

> The Spanish Guitarist c.1876

Oil on canvas

SPANISH MUSIC was much in fashion in Paris in the 1870s (Bizet's *Carmen* was written in 1875), with the flamenco guitar being particularly popular. Perhaps its sound had a special appeal to northern Europeans hankering after the exotic atmosphere of the southern

Mediterranean. In this picture, Renoir put the sitter in what look like a matador's 'suit of lights'. He was to do the same thing some 30 years later when he painted the dealer Ambroise Vollard wearing the 'suit of lights' he had brought back after a visit to Spain.

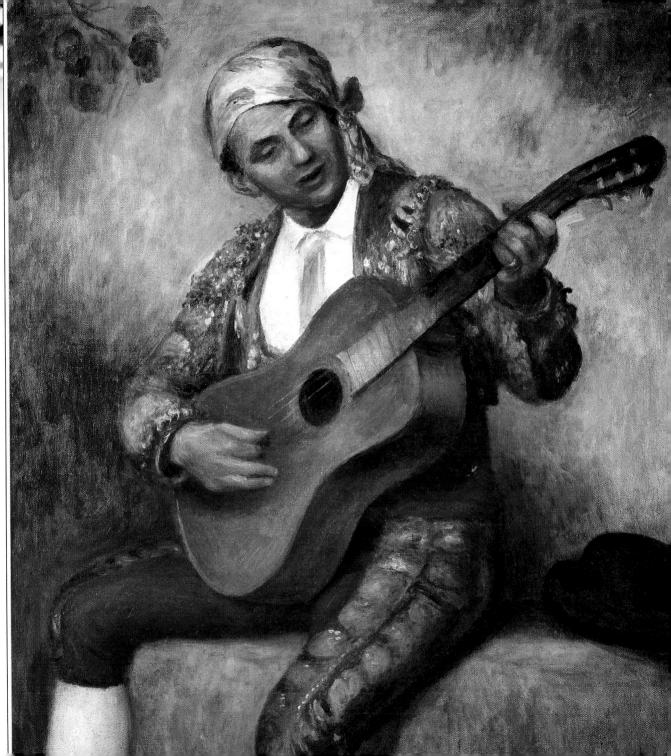

▶ The Moulin de la Galette 1876

Oil on canvas

THE MOULIN DE LA GALETTE was an open-air dance-hall on the hill of Montmartre, outside the tax belt of Paris, and was a favourite meeting-place for the lower bourgeoisie of the city, who could enjoy drinking cheaply in its acacia-shaded courtyard, while meeting the opposite sex with propriety. Renoir painted the Moulin in 1876 as a *tour de force* to show off his talent to the art-loving

public. Like the *Lunch of the Boating Party* a few years later, it shows his extraordinary talent for scenes composed of many people engaged in different activities. Most of the men and women in this picture were Renoir's friends and included dancers, writers and painters. Renoir painted several versions of the scene; this one is the best-known version in The Musée d'Orsay in Paris.

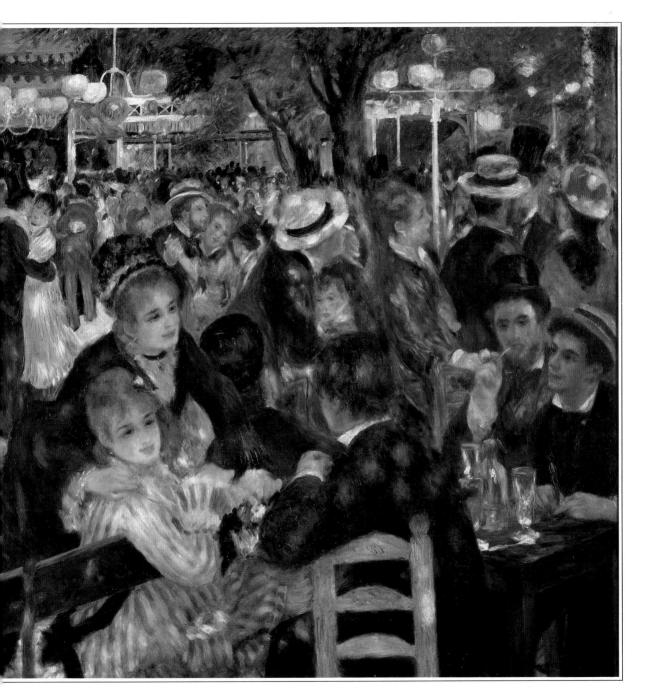

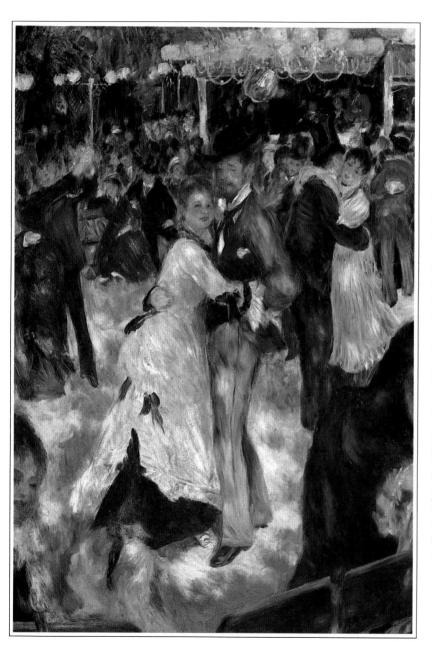

Oil on canvas

This detail of the Musée d'Orsay's version of the Moulin de la Galette in Montmartre is interesting as a study of how the Impressionist technique was used by Renoir. The brushstrokes were laid on separately in order to give a lively surface which emulated light reflected off an object and colours were used pure for the best effect, instead of mixed together as was the custom with academic painters whose canvases had a fashionable brown look. Pissarro had laid down the basic principles for Impressionism by recommending that the basic palette should be the three primary colours red, yellow, blue and the complementary colours orange, green, violet, the effect of which was created by placing brushstrokes of the primary colours side by side and allowing their mixture to take place in the viewer's eye.

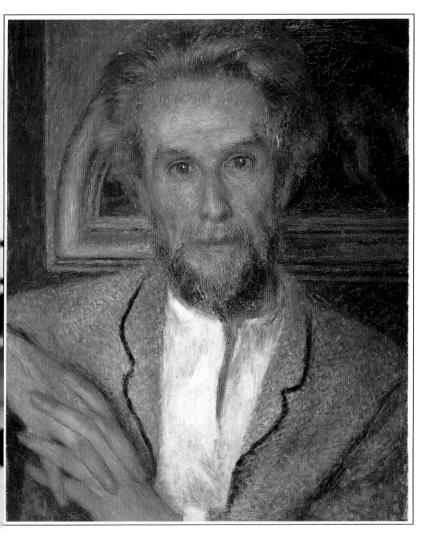

○ Portrait of Victor Chocquet 1876

Oil on canvas

VICTOR CHOCQUET was a customs official and art-lover who championed the Impressionist painters at a time when they had little public support. He met Renoir at the unsuccessful Hôtel Drouot exhibition in 1876 and first commissioned him to paint a portrait of his wife. This portrait of Chocquet was painted a year later. Renoir enjoyed the company of other men and sometimes complained of being bored at home with too much female company. In this portrait there is an evident rapport between artist and sitter whom Renoir shows as a sensitive, intellectual, good-humoured man.

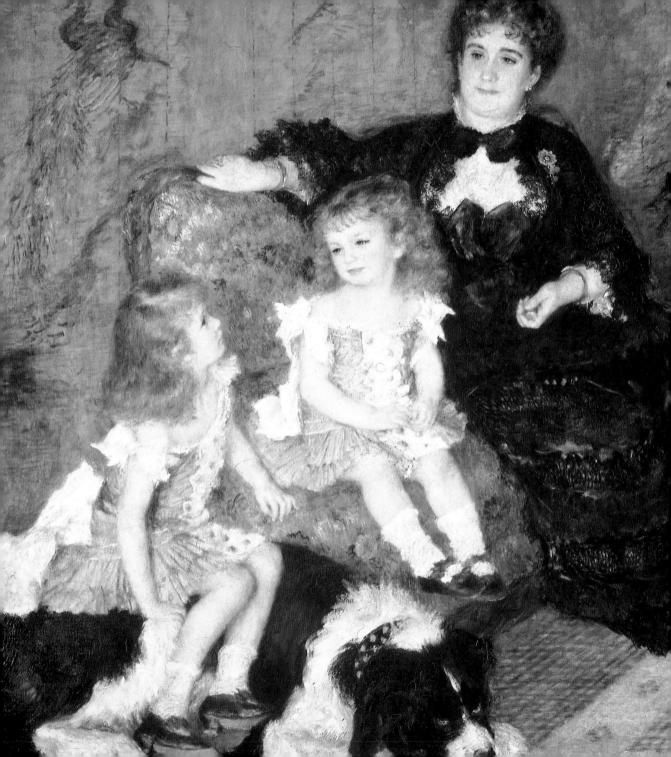

Oil on canvas

WITH THIS PAINTING, Renoir achieved what he had set his heart on: acceptance by the Salon. The painting was a big success at the 1879 Salon and brought him the patronage of wealthy people and the financial security needed to carry on with his experimental Impressionism. M. Georges Charpentier was a publisher and he and his wife had a notable salon of intellectuals. Renoir visited them in their seaside home at Pourville, near Dieppe, where he painted by the sea and met Paul Berard, an embassy secretary who also commissioned work from him.

⊳ La Place Pigalle c.1880

Oil on canvas

AT VARIOUS TIMES in his life Renoir took a leaf out of his painter friends' notebooks; with Monet he painted a scene at La Grenouillère on the Seine, and after visiting Cézanne at Aix he painted Mont Sainte-Victoire. Here, he seems to be doing a Degas street scene: the people hurrying in and out of the picture give it the snapshot quality of a Degas composition, though one glance at the face of the girl in the foreground is enough to tell you that it is by Renoir. The scene is in the Place Pigalle in Montmartre, a quarter of Paris which was a great centre of entertainment, even in Renoir's day.

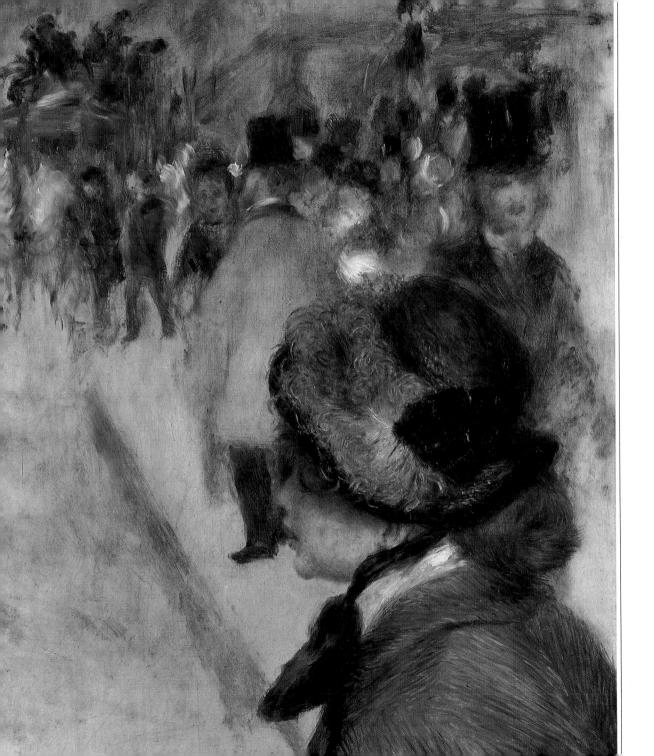

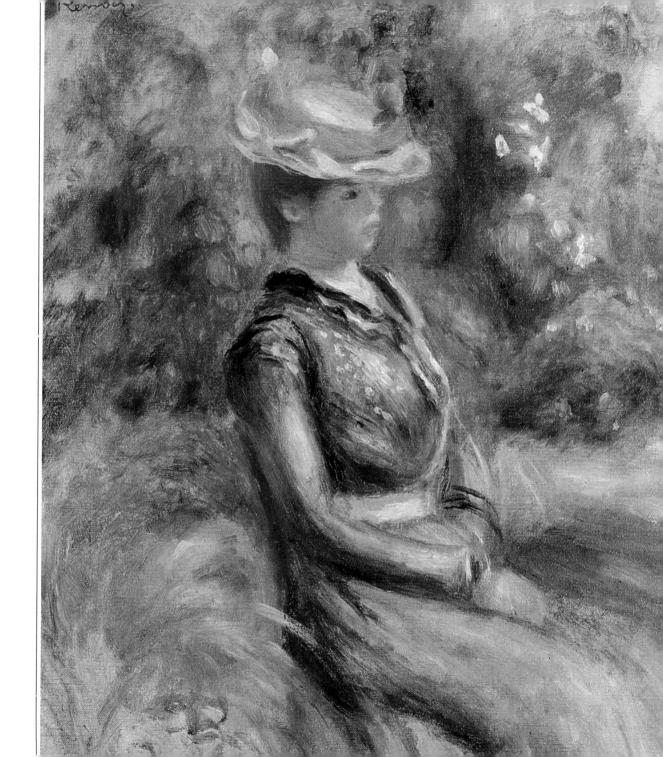

☐ Girl Wearing a Straw Hat

Dil on canvas

THE CHARMING YOUNG LADIES wearing attractive hats who eatured in so many of Renoir's paintings seem to be the termanently suspended in a world of innocence and insolution as world where beace and happiness reigned and daily life was full of jolly events. To many of his ontemporaries, Renoir was in 'escapist' painter, looking

at the pleasant side of life rather than investigating its seedier or more intellectually demanding aspects.

Not for Renoir the tired dancing girls and prostitutes who were the subject of so many of Toulouse-Lautrec's paintings, or the intellectual wrestling with form and content which marked so much of Cézanne's work.

Detail

▶ Railway Bridge at Chatou 1891

Oil on canvas

RENOIR DID NOT PAINT many landscapes; but this is a charming exception with the railway bridge hiding behind the flowering chestnut trees and a figure, perhaps the artist himself, standing in the gap in the fence with

the river beyond. It was painted at Chatou, one of several places on the Seine out of Paris – Bougival and Asnières were others – which were to become famous as a result of the Impressionists work there.

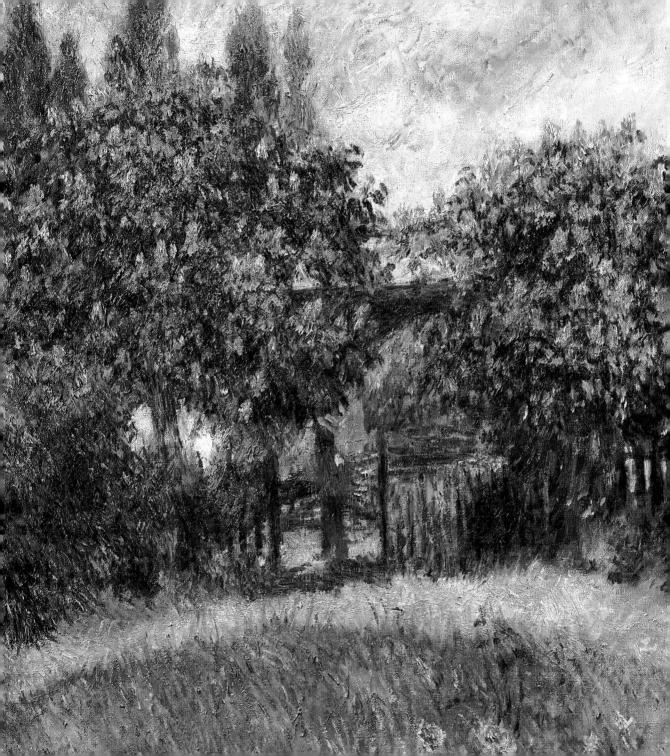

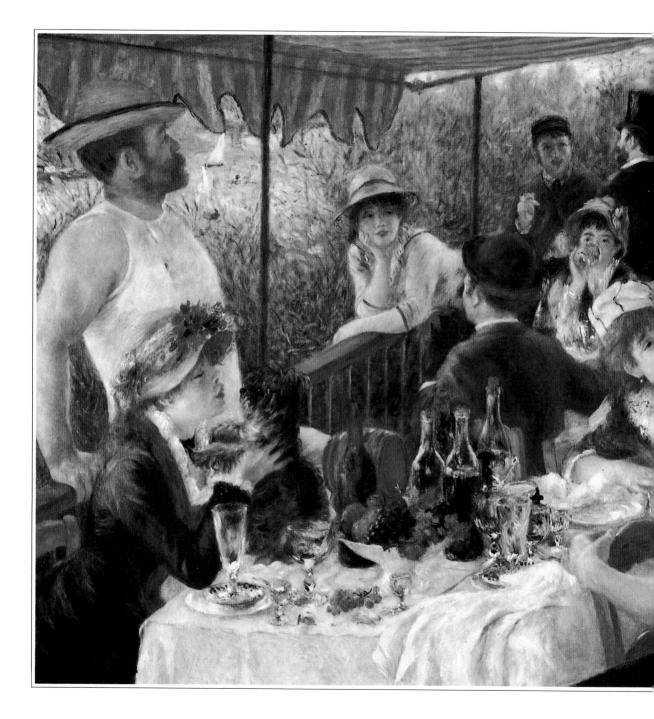

⊲ The Luncheon of the Boating Party 1881

Oil on canvas

RENOIR'S FRIENDS admired this lively painting of a boating party in which some of them appear: the lady with the dog, for instance, is Aline Charigot, later Renoir's wife. The picture was undoubtedly intended as a *tour de force*, and one Renoir had been thinking about for some time. 'I have been itching to do it for a long

time,' he wrote to Paul Berard. 'I am not getting any younger and I did not want to delay this little feast.' In fact, Renoir was nearly 40 and his best painting years were to come. But on the threshold of middle age he was beginning to feel intimations of mortality – or, at least, a need for a change of direction.

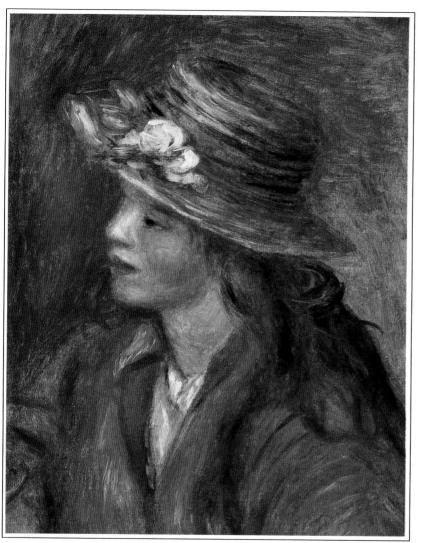

✓ Young Girl in a Straw Hat

Oil on canvas

HATS AND ABUNDANT HAIR often appear in Renoir's paintings, framing or half-hiding the face and giving an air of mystery to what might otherwise be rather ordinary features. In some cases, Renoir is clearly interested in the model, especially if they are his family or friends; in others, as with his nudes, the model is simply an object that starts a train of thought about the painting. The model was also essential. Renoir said, because if his ideas about the painting began to get out of hand he needed the model to bring him back to earth.

> Young Girl Wearing a White Hat

Oil on canvas

Another pretty GIRL, another pretty hat. The theme turns up again and again in Renoir's work. One of the most evocative items amongst the many relics of the artist's life in his studio at Les Collettes, his villa at Cagnes-sur-Mer, is the straw hat, its crown encircled with artificial flowers, which lies near his easel. It is as if it waits for the artist to reach out, put it on his model's head, and start another charming portrait.

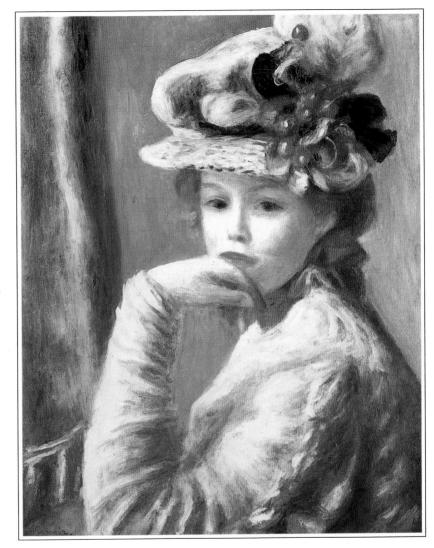

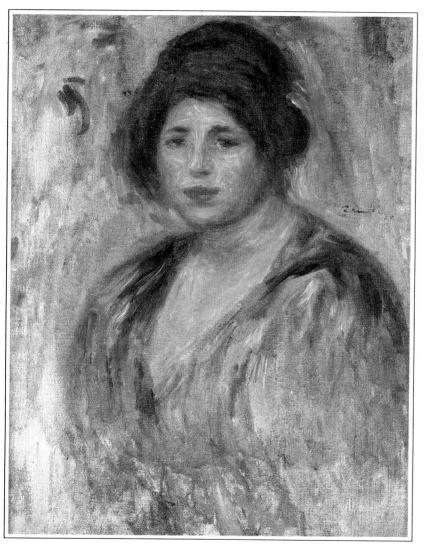

☐ Young Woman in a Fur Hat

Oil on canvas

RENOIR ABANDONED the airs of summer for this portrait of a girl in a fur hat. The treatment is simple, the absence of the abundant hair which featured in so many of Renoir's 'girls with hats' pictures is also unusual. Perhaps he was deliberately seeking a more severe style of drawing in line with the classical tradition he had come to admire so greatly.

> Umbrellas Les Parapluies) c.1886

Oil on canvas

Imbrellas was painted during he period when Renoir was rying to break away from his Impressionist style and tighten is line and structure. Visits to Italy and to Cézanne at ¿Estaque in the south of France had a profound effect on him and he felt liscouraged about his previous vork. He had also decided to vork more in the studio than outdoors because, he said, outdoor painting is too complicated an affair, a kind of painting that makes you constantly compromise with ourself.' *Umbrellas* is really wo paintings, for the figures on the right are still in the mpressionist style while the igures on the left and the imbrellas themselves show Renoir's new preoccupation vith form in a Cézanne nanner. Later, Renoir nanaged to fuse the two ways of painting, creating some of iis greatest works.

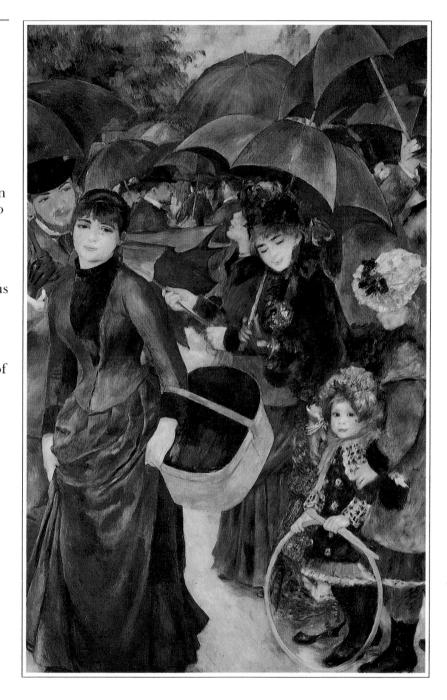

⊳ Richard Wagner 1882

Oil on canvas

IN 1881 RENOIR visited Italy, making his first contact with the Greek and Roman cultures and with the work of the Renaissance painters, which so impressed him that he had to re-assess the value of what he had done so far. While in Sicily he met the great maestro Richard Wagner who was in the midst of writing Parsifal. The notoriously temperamental composer agreed to give Renoir a sitting of 25 minutes, during which time the painter produced this portrait, probably the last of the famous composer, for he died in 1883.

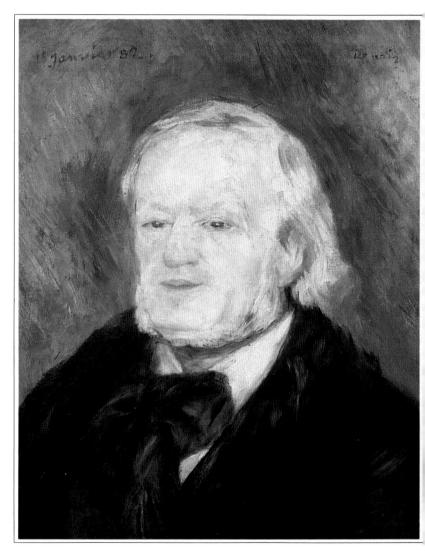

> Dance at Bougival 1883

Oil on canvas

IN 1882-3 RENOIR painted three nearly life-size pictures of couples dancing. Two were the deliberately contrasted Dance in the Country and Dance in the City. The couple dancing here seem, in contrast to the other two, to be in an ambience that is neither city nor country. The pencil sketch for Dance at Bougival shows a much more rural pair with a girl, though wearing a long dress, less smartly turned out and the man a more clumsy and countrified character. Evidently Renoir decided to smarten them both up in the finished painting. Once again, Renoir used friends as his models. The man in all three pictures was his old friend, Paul Lhote; the girl, both here and in Dance in the City, was a circus acrobat called Maria Clémentine who later became famous as the artist Suzanne Valadon, mother of Maurice Utrillo.

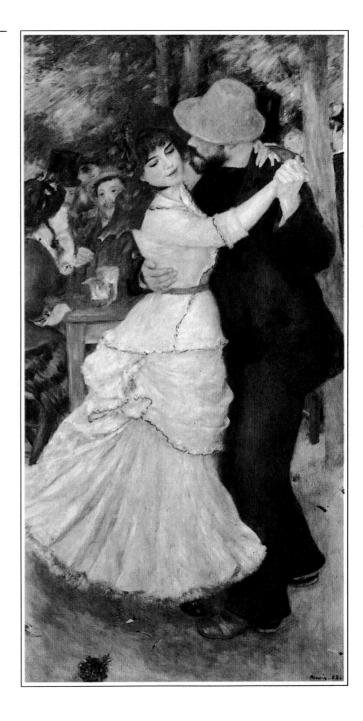

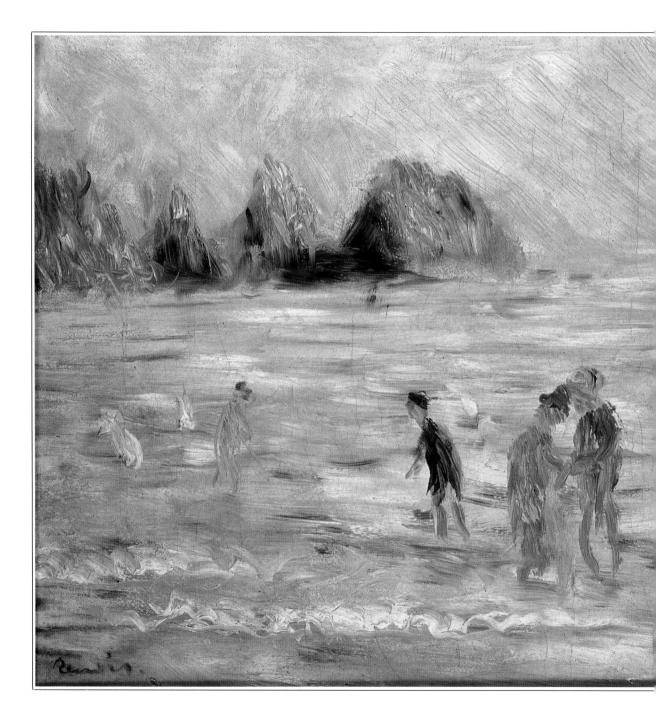

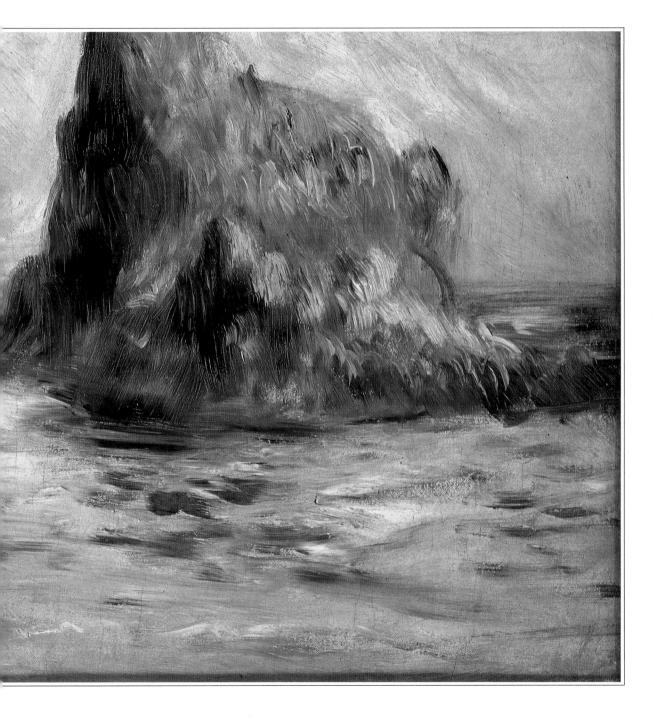

Moulin Huet Bay, Guernsey 1883

Oil on canvas

RENOIR VISITED JERSEY and Guernsey briefly in September 1883, just after the exhibition organized for him by the dealer Durand-Ruel. As he usually did when travelling, he made numerous sketches and some paintings of his surroundings, finding a certain affinity with the landscape,

which resembled that of the coast of Normandy. The break in the Channel Island coincided with a hiatus in Renoir's work, about which he wrote to Durand-Ruel saying that he had reached the end of Impressionism and had come to the conclusion that he did not know how to paint or draw.

▷ Bather with Long Hair

Oil on canvas

THIS EXCEPTIONALLY fine nude shows Renoir's penchant for long hair and his artistic mastery of the nude figure. Jean Renoir once quoted his father as saying, 'It is with my brush that I make love', meaning that the act of carefully and sensitively building up the layers of paint to produce that glowing life of

his nudes was an act of love for life itself. Unlike Cézanne, who explored the structure of objects, Renoir wanted to express the quality in tangible and visible things which convey a feeling of living matter. In his nudes he depicts not so much sensuality as an idealised vision of the élan vital.

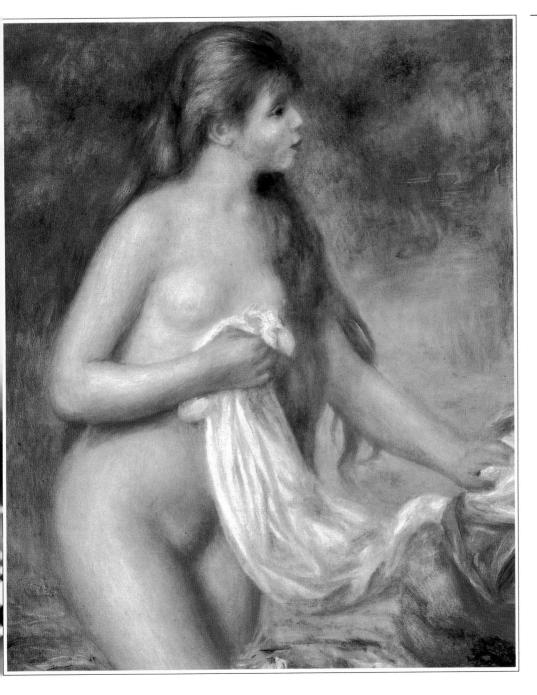

Detail

Portrait of Monet 1875

Oil on canvas

The portrait of Claude Monet in his midthirties was exhibited at the second Impressionist exhibition. It is not only a revealing portrait of the artist but evocative of all the young friends and companions in the new movement in painting, whose world had not yet received general acceptance by the public. Monet himself was

in financial difficulties, though his letter to Manet – 'It's getting more and more difficult. Not a penny left since the day before yesterday, and no more credit at the butcher's or the baker's. You couldn't possibly send me a 20 france note by return of post. Could you?' – could have been written by several of the Impressionists of the time.

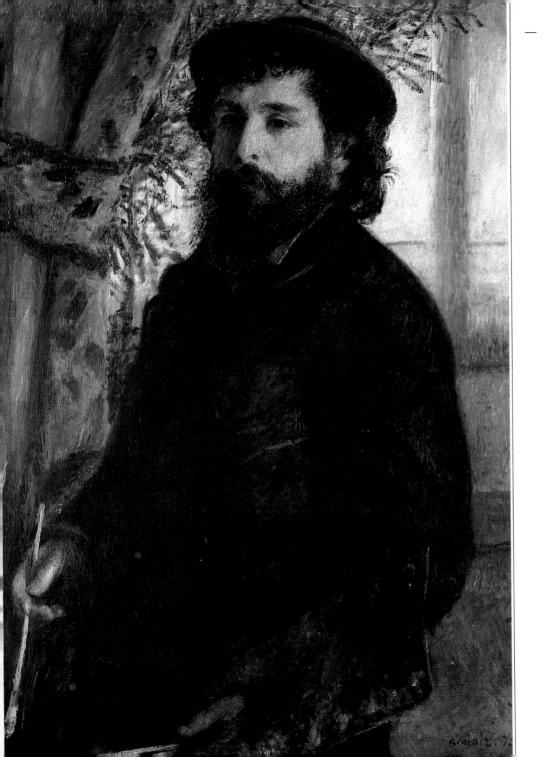

Oil on canvas

IT TOOK THREE YEARS of endless sketches and preparatory versions for Renoir to be satisfied with this painting, in which he was trying to return to a more classical line of drawing. Its more precise, harder modelling has been called Renoir's manière aigre. The painting was well received except by his friend Pissarro, who thought that Renoir's visit to Italy and his subsequent attempt to change his style was a mistake, and had led to a loss in the colour value of the picture. In order to tighten his line, Renoir had studied Ingres, and the influence of the French classicist is visible here.

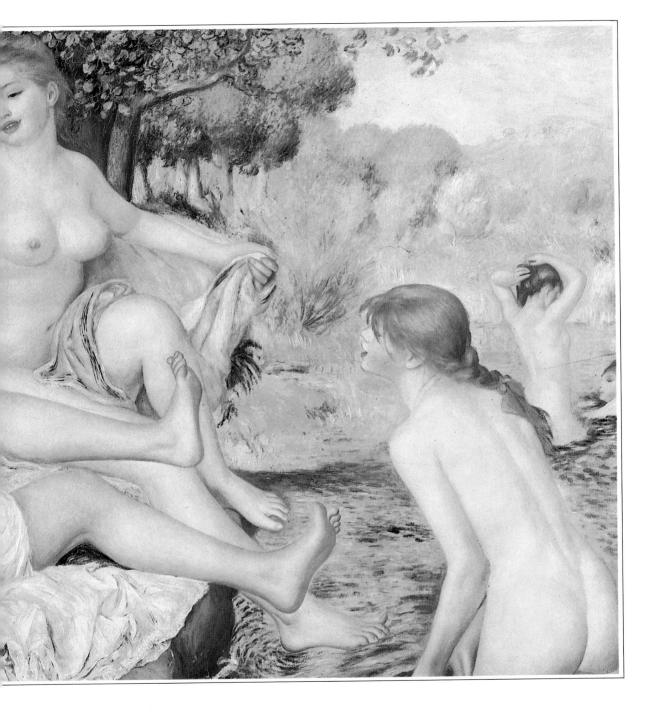

▶ Mother and Child 1886

Oil on canvas

THE MOTHER AND CHILD in this charming picture are Aline Renoir and Pierre. It may be coincidence but Renoir's 'Hard line' style, adopted after his visit to Italy and his discovery of such Renaissance masters as Raphael, had begun to soften at about this time. He now

returned to the atmospheric style of his earlier paintings though with a more monumental form which would later become apparent in the sculpture he began doing when increasing arthritis made it difficult for him to hold a paint brush.

Detail

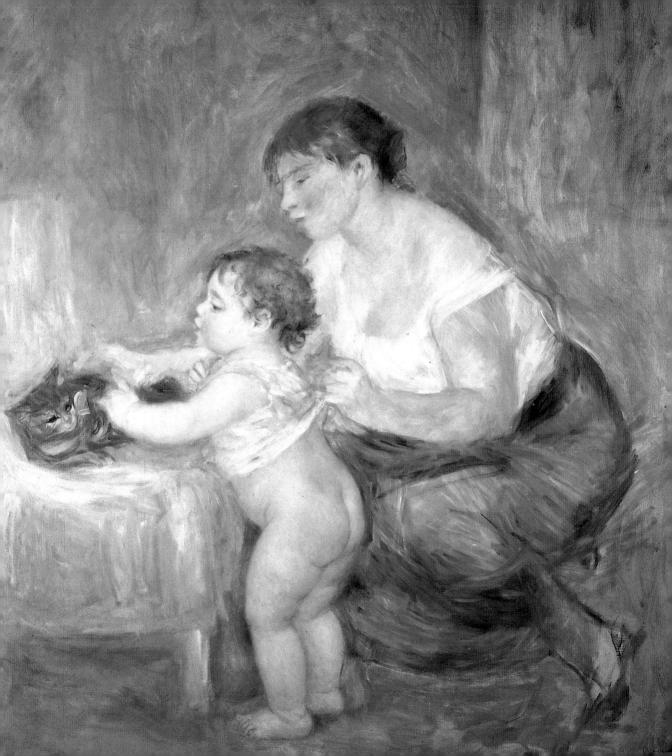

▶ Pierre Renoir 1890

Oil on canvas

PIERRE RENOIR was Renoir's eldest son, born in 1885 to Aline Charigot, Renoir's longtime model whom he married the year that this picture was painted. Aline had been with Renoir at least ten years, for she appears in the Luncheon of the Boating Party of 1880 and had given him moral support during his personal artistic crisis when he had become disillusioned with his Impressionist style of painting and had sought another solution. Pierre's birth was to inspire a delightful series of family paintings, beginning with one of Pierre at Aline's breast.

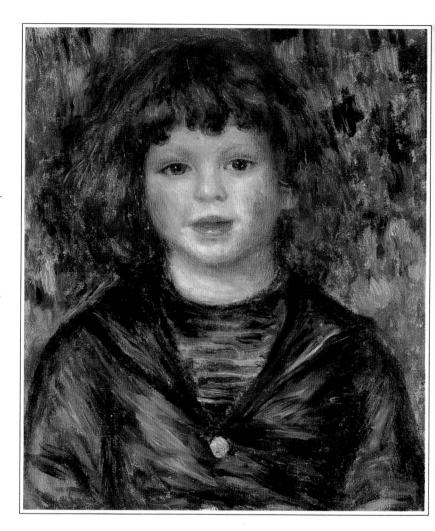

▶ Portrait of the Poet Stéphane Mallarmé

Oil on canvas

FRENCH POETRY has always reflected philosophical ideas, particularly in the 19th century when France was in a state of political and cultural turmoil after the Napoleonic era. Mallarmé, a contemporary of Renoir, believed that poetry was the expression of the mysterious meaning of existence and gave the only form of authenticity to life on earth. In this way, he was a precursor of the existentialist idea that the only reality is the one that you are living in. Such an idea accorded well with the Impressionist aim of recording nature as actually seen. In 1891 Renoir made several engravings for the poet's book, Pages.

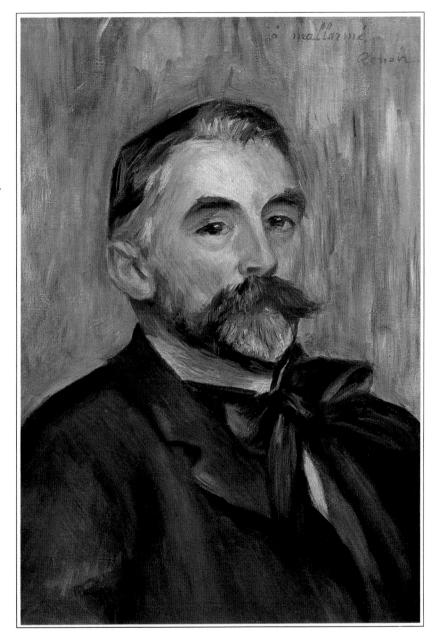

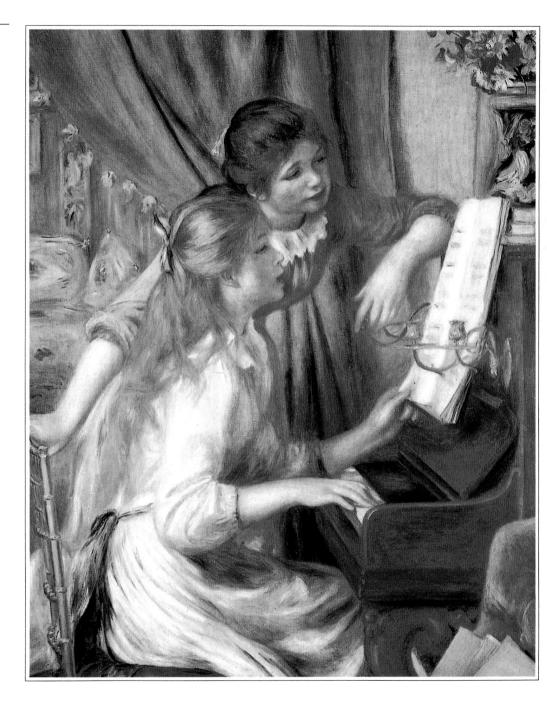

✓ Young Girls at the Piano c.1892

Oil on canvas

AFTER HIS MARRIAGE, Renoir seemed to discover the joys of domesticity, and from this time he would paint many paintings of his and friends' children. By 1890, Renoir had moved on from his severely linear, classical manner and had developed a technique which combined the colourfulness of Impressionism with the

solidity of the old masters. In this painting of two young girls at the piano, Renoir gives a glimpse of the domestic life of his time when almost every household had a piano with brass candleholders and young sons and daughters of the bourgeoisie were encouraged to take up artistic interests such as music, singing and painting and drawing.

Gabrielle and Jean 1895

Oil on canvas

▷ Overleaf page 58

THE EMOTIONAL CONTENT of Renoir's domestic scenes is particularly strong in paintings of his children. This one of his second son Jean and Gabrielle gives a strong feeling of the attachment between the boy and the girl; she had joined the Renoir household at the age of 16 and had become very much one of the family as well as Renoir's favourite model.

In Renoir's close-knit family group everyone understood that painting came first in his life and there were no competing interests.

Thus, all his family posed for him, though the children sometimes did so reluctantly and had to be threatened or bribed to persuade them to sit

or stand still.

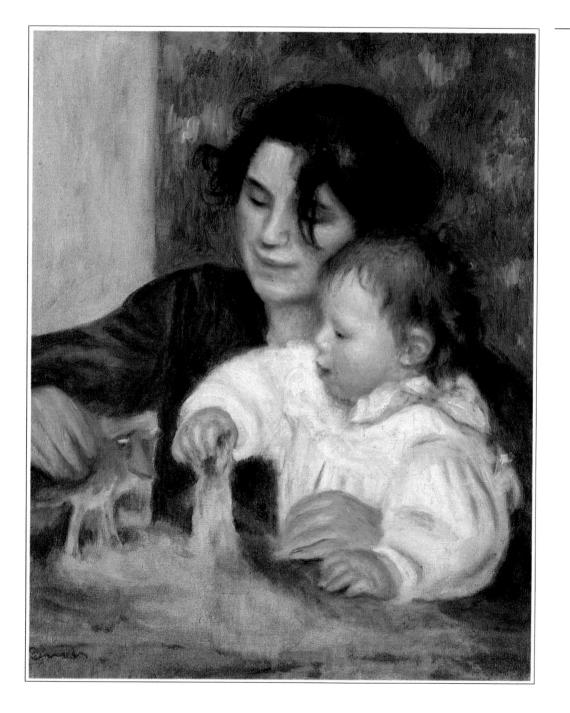

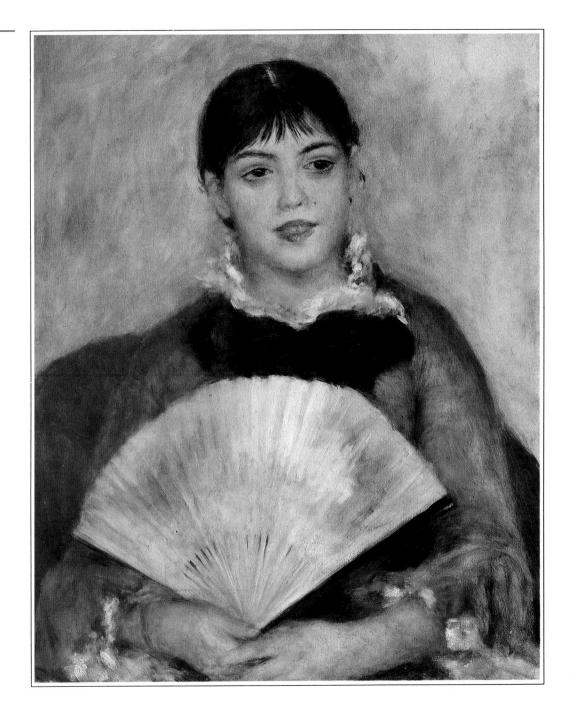

Girl with a fan 1880

Oil on canvas

△ Previous page 59

THIS DARK-HAIRED GIRL is Alphonsine Fournaise who also posed for another Renoir portrait the year that he broke his arm and had to paint lefthanded but with no ill effect on his work. The fan gives a certain Japanese flavour to the picture, an influence perhaps derived from the Japanese

prints that had been much admired by other Impressionist painters, in particular van Gogh and Gauguin. The fan with its sharp diagonals and its rounded top, which echoes the shape of the girl's shoulders, makes an interesting addition to an otherwise conventional portrait pose.

▶ Young Girl Drawing

Oil on canvas

THE YOUNG GIRL in this painting, with her reddish hair and pink cheeks, bears a likeness to Renoir's youngest son, Claude. Like many painters, Renoir tended to give all his sitters a distinctive 'look'. His girls had dark hair and elongated, cat-like eyes – 'Cats

are the only women who count, the most amusing to paint', Renoir once remarked to his son, Jean – and his men had romantically long hair, dark eyes and beards. Even so, his friends and family, who all sat many times for the artist, are all recognizable in their portraits.

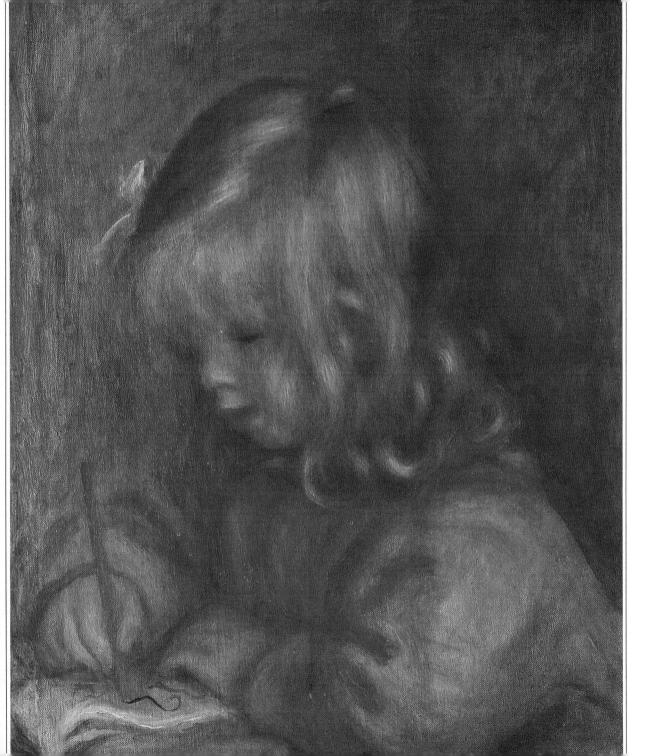

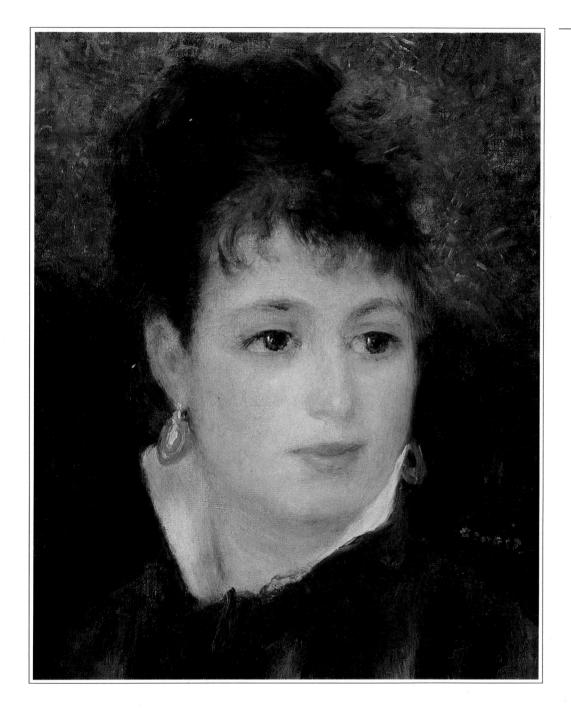

△ Woman with a Rose

Oil on canvas

THIS HEAD OF A WOMAN is in the style of the portraits of the 1870s that were making Renoir's work acceptable in the Salon and, more importantly, to the picture-buying society of Paris. Renoir's talent in producing pictures that combined academic acceptability with a new style of painting made life financially easier for him, moreso than it was for artists like Monet. It enabled him to follow his own artistic path.

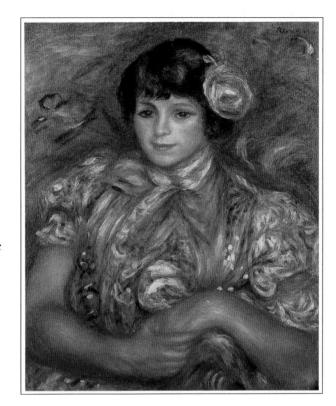

\triangle Women with a Rose 1900

Oil on canvas

ROSES WERE A FAVOURITE flower for Renoir, who did fewer flower paintings than other artists of his period. The open, soft-edged petals of roses and their texture appealed to the painter, just as a woman's skin did. When combined, the two gave Renoir new inspiration and, as he told Ambroise Vollard, he found that in discovering new ways of painting the petals he also learned how to enhance his painting of the skin of his nudes.

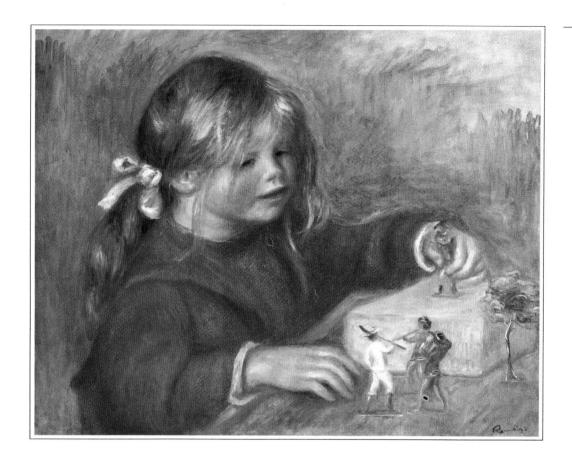

\triangle Claude Renoir Playing 1905

Oil on canvas

CLAUDE RENOIR, known in the family as 'Coco', the third son of the painter and his wife Aline, was born in 1901 when Renoir was sixty. It was the year after Renoir's great Paris success at the Centenaire, to which he had

sent 15 paintings. At last he had arrived as a painter, was accepted by the establishment and had been awarded the *Chevalier de la Légion d'Honneur*. In spite of his success, Renoir remained a simple man,

attached to his family and, as he himself said, 'I feel a simple little man.' This child-like simplicity, that remained with him all his life, made his nudes so pure and his children's paintings so perceptive.

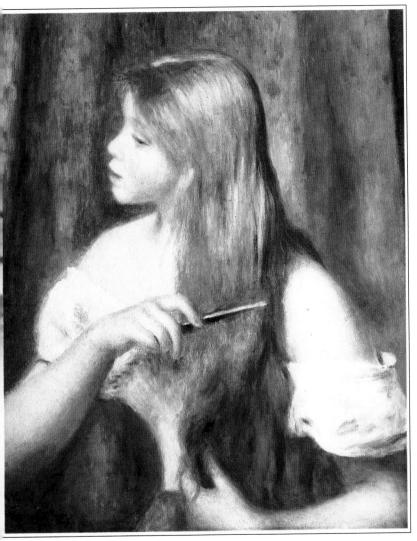

⊲ Girl Combing her Hair

Oil on canvas

RENOIR IS BEST KNOWN for his paintings of women, often nude and usually suggesting some aspect of domestic life rather than an abstract sexuality. This young girl is performing the same sort of everyday ritual as Degas's women having baths or ironing their clothes. The Impressionists' choice of such subjects, long considered beyond the bounds of good taste in art, reflects the new acceptance of people as people instead of as symbols of social status.

▷ Treboul, near Douarnenez 1895

Oil on canvas

WHILE ON HOLIDAY at Douarnenez on the Atlantic coast of Brittany, Renoir managed to paint both seascapes and inland pictures. Unlike Monet, Renoir was not particularly attracted by the sea or by landscapes in

themselves, preferring to use them as backgrounds for people. Sometimes, however, he made sketches of places that attracted him, rather in the style of a modern holidaymaker taking snapshots for the photograph album.

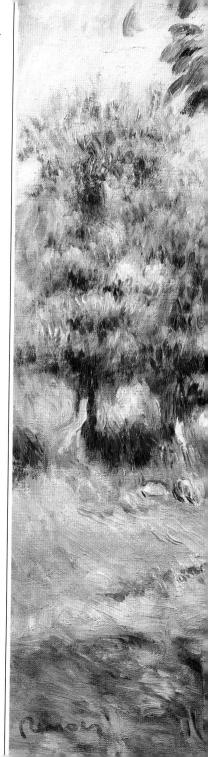

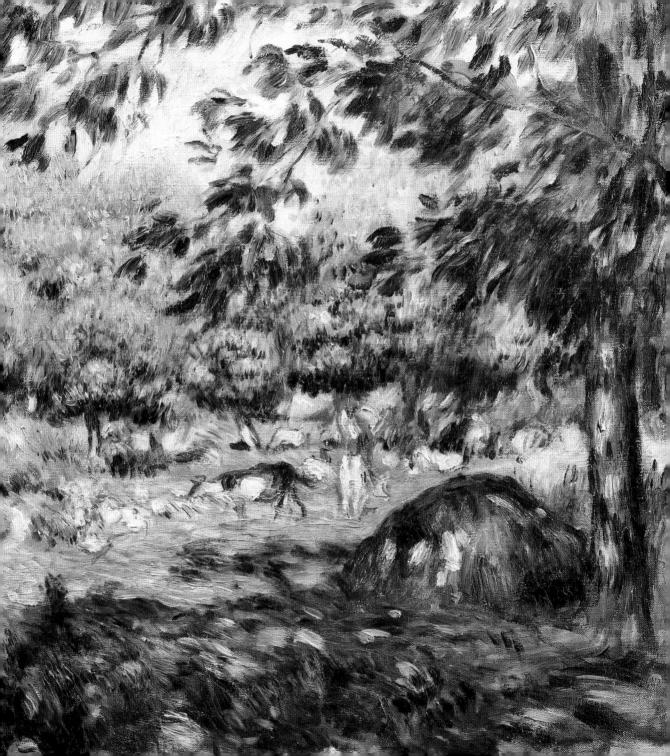

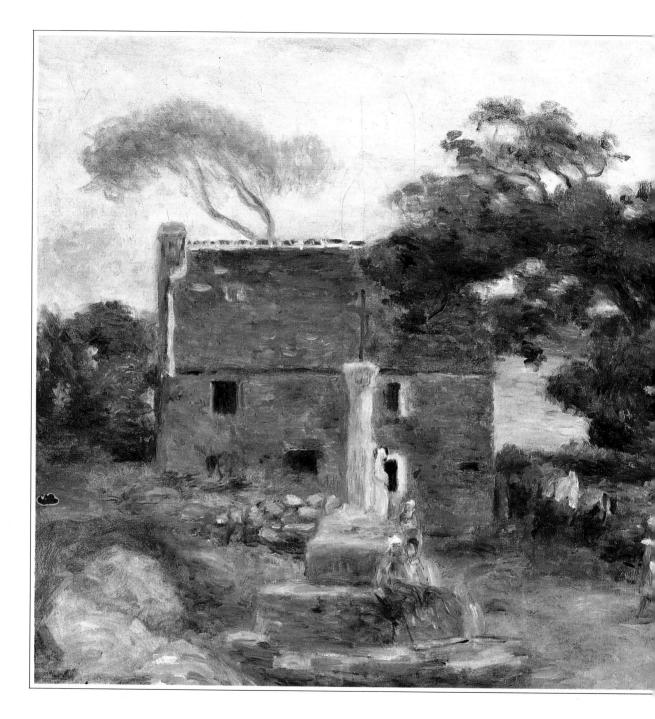

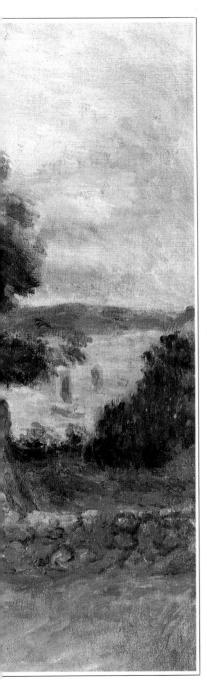

\triangleleft The farmhouse at Cagnes c.1908

Oil on canvas

RENOIR AND HIS FAMILY began visiting Cagnes, in the south of France near Nice, in 1885 and eventually built a house in an ancient olive grove, on the slopes of the hill near the old Grimaldi château. Renoir hoped that the warm winters would help his arthritis and enable him to continue painting – which they did, though his disability, which

crippled his fingers and paralysed his legs, was never cured. In Cagnes, Renoir continued to paint almost until his death in 1919 and enjoyed with his family and three sons a near-idyllic family and artistic life. Visitors to his villa at Cagnes, Les Collettes, may still experience something of the idyll in this haven of peace and quiet.

▶ A View of Cagnes c.1900

Oil on canvas

THIS VIEW OF CAGNES shows that when Renoir first discovered the small village to the west of Nice and the River Var the area was still very rural. He took an immediate liking to it, and decided it was right for a winter haven where the warmth would help his arthritis. Some years after his first visit in 1888, he began building a house in an ancient olive grove on the slopes facing the hill top and with a view of the sea over fields and woods. The family moved

into Les Collettes in 1903. Renoir's property has been preserved much as he left it, and his studio has been furnished with his easel and wheelchair, model's throne and other impedimenta of his working life. The present house (built in 1908) contains many of his drawings and paintings and the ancient olive grove is still there but the view, alas, has mostly disappeared under the concrete of modern developments.

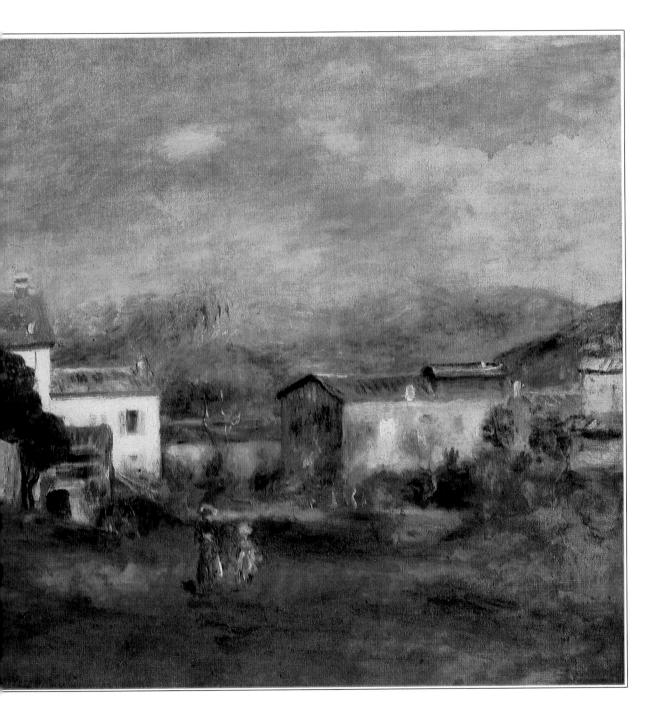

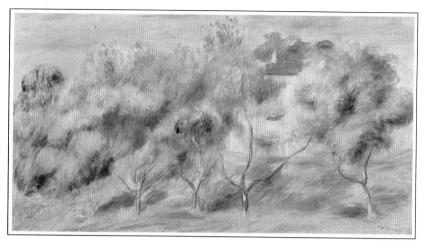

△ Les Collettes, Cagnes-sur-Mer c.1908

Oil on canvas

FOR THE LATTER PART of his life, Renoir divided his year between two properties, spending his summers at Essoyes in Burgundy and his winters at Les Collettes in the south of France near Nice. In 1908 he built his own house at Les Collettes, in the midst of a grove of ancient olive trees. Despite increasing physical

difficulties caused by crippling arthritis and rheumatism, Renoir's years at Les Collettes were wonderfully productive, both in painting and in sculpture. Today, Renoir's property at Cagnes-sur-Mer is a museum, allowing visitors a glimpse into the artist's life and the inspiration of some of his greatest work.

▶ Portrait of Ambroise Vollard 1908

Oil on canvas

THE IMPRESSIONIST movement was for some time largely derided by the public, who were used to the old forms of academic art and were unable to understand the new way of seeing the life around them. There were always one or two stalwart supporters of the new painters, one of whom was Ambrose Vollard, a Paris art dealer who became a friend of Renoir in the 1890s and sat for him on several occasions. In this one, he admires a statue by Maillol. Cézanne also did a portrait of Vollard, but his took 100 sittings while Renoir kept Vollard away from his work for a much shorter time.

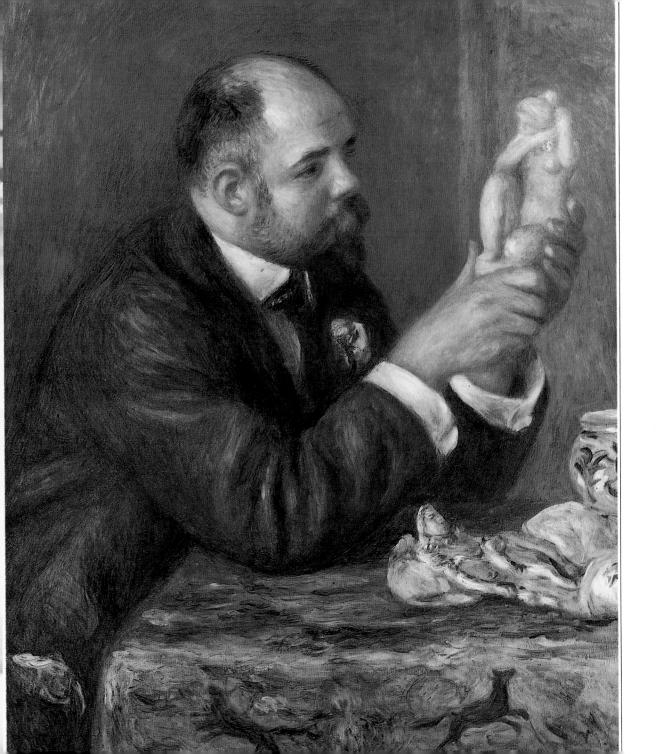

Ambroise Vollard 1908

Oil on canvas

THERE IS NO DOUBT that Ambroise Vollard was well regarded by the Impressionist painters and that as well as being their dealer he was a friend. In a letter to Charles Camoin, the painter, Cézanne wrote that the Bernheimes and another dealer had been to see him. 'But I remain true to Vollard.' In his autobiographical book 'Recollections of a Picture Dealer', Vollard recounts many anecdotes about Renoir, Cézanne and other painter friends. When he visited Renoir at Essoyes and asked him why he lived there instead of Paris, Renoir replied 'The butter here is perfect and the bread better than you get in Paris. And then there's the good little vin du pays.'

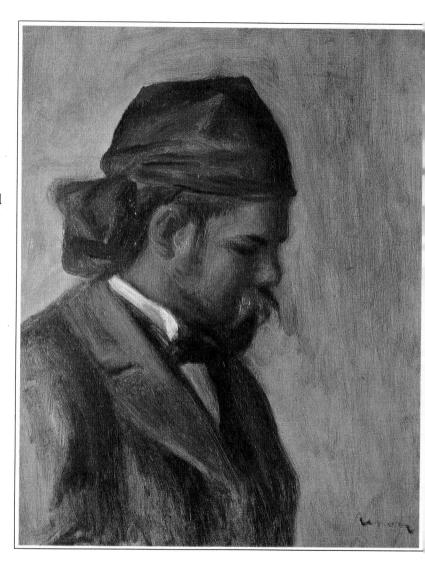

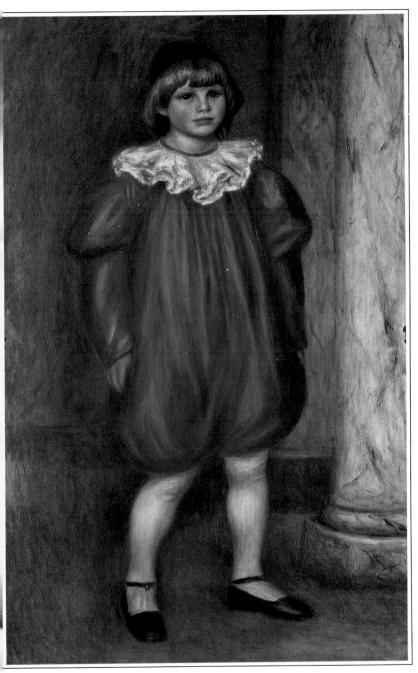

Oil on canvas

CLAUDE RECALLS in his 'Souvenir sur Mon Père', published in 1948 in a book entitled Seize Aquarelles et Sanguines de Renoir, that he was very reluctant to pose in the clown's costume in which he appears in this painting. He was particularly against wearing the white stockings his father insisted on because they made his legs itch. There was a long tussle between the father and his young son in which Renoir threatened a spanking for disobedience but in the end had to resort to bribery, promising young Coco an electric train and a box of paints.

Dancing Girl with a Tambourine 1909

Oil on canvas

This is one of a pair of paintings, the other being a girl with castanets, (modelled by Gabrielle Renard), which was commissioned for the dining-room of M. Maurice Gangnat, one of Renoir's patrons. The exotic character of the subject seems to relate to the Woman of Algiers which Renoir had painted in 1870. Then, Renoir saw it as a tribute to Delacroix, but now, 39 years later, perhaps it was just a memory of his youthful visit to North Africa. According to Georgette Pigeot, who modelled for this picture, the girls in both were to have been depicted holding fruit, but the Gangnats decided on the change to musical items, so that the pictures could be hung in other living-rooms.

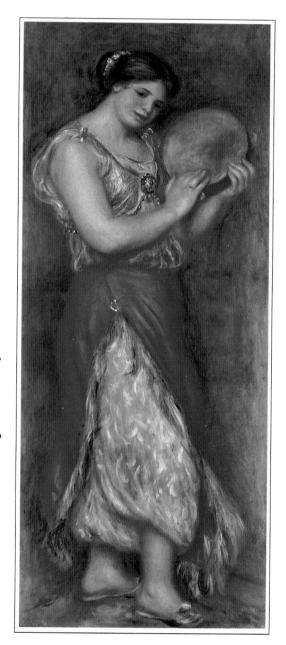

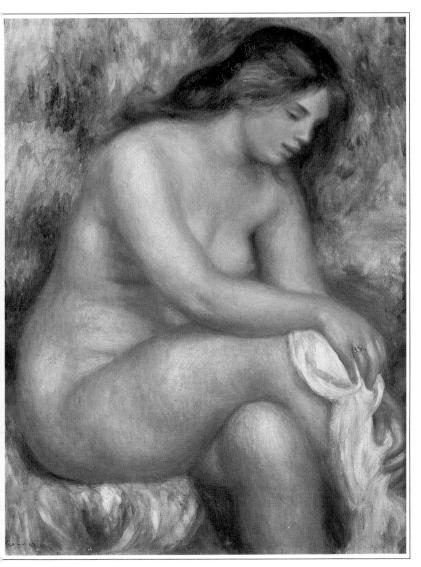

Oil on canvas

By 1910, RENOIR's arthritis had grown severe enough to make holding a brush a difficult and painful business. Although he became depressed and threatened to give up painting, he did not give in. When his fingers became twisted and immobilised by the disease, he had brushes strapped to his hand so that he could continue. He not only managed to paint another great version of the Grandes Baigneuses but many other nudes, including this version of a girl drying her legs. The richness and luminosity of the flesh tones show that his disability had not affected his sensitive touch.

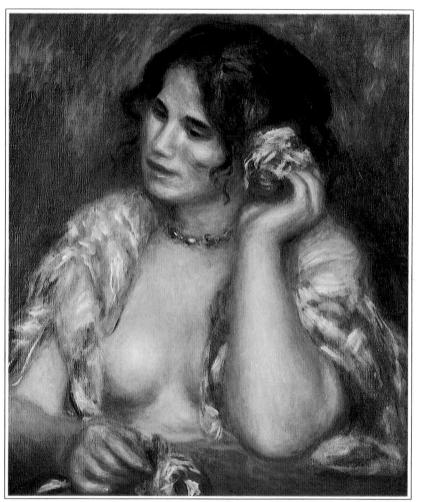

Gabrielle with Roses 1911

Oil on canvas

GABRIELLE RENARD was part of the Renoir family from the time that their second son, Jean, was born in 1894 and took on the roles of nurse, mother's help and model with admirable equanimity. Until then, Aline had been Renoir's in-house model but from now on she appeared as wife and mother in his paintings. In this painting Renoir shows his mastery of both colour and structure and has given it all the solidity and breadth of the old master paintings that he admired so much and had wanted to emulate after his stimulating visit to Italy in 1881. Both Gabrielle and roses were to be used constantly by Renoir as the main inspiration of many of his finest paintings.

ACKNOWLEDGEMENTS

The Publisher would like to thank the following for their kind permission to reproduce the paintings in this book:

Bridgeman Art Library, London Art Institute of Chicago 14, 15: /Chateau de Versailles, France 55; /Christie's, London 18, 22, 23, 32, 33, 39, 40, 54, 62, 68-69; /Courtauld Institute Galleries, University of London 13, 73; /Fogg Art Museum, Cambridge, Mass. 27; /Giraudon/Musée d'Orsay, Paris 24-25, 26, 34-35, 38, 42, 47, 58, 64; /Giraudon /Musée de L'Orangerie, Paris 75; /Hermitage, St Petersburg 59; /Kunsthalle, Hamburg 12; /Louvre, Paris 78; /Metropolitan Museum of Art, New York 28-29, 65; /Musée d'Orsay, Paris 48, 49, 56; /Musée du Petit Palais, Paris 74; /Museo de Arte Sao Paulo, Brazil 77; /Museum of Fine Arts, Boston, Mass. 43; /National Gallery, London 41, 44-45, 76; /National Gallery of Art, Washington DC 20, 21; /Neue Pinakothek, Munich 19; /Palace of the Legion of Honour, San Francisco 52, 53; /Philadelphia Museum of Art, Pennsylvania 50-51; /Phillips Collection, Washington DC 36-37; /Private Collection 16-17, 30, 31, 61, 63, 66-67, 72; /Pushkin Museum, Moscow 10-11; /Saarland Museum, Saarbrucken 70-71; /Wallraf-Richartz Museum, Cologne 9.